WESTON-SUPER-MARE
HISTORY TOUR

First published 2018

Amberley Publishing
The Hill, Stroud,
Gloucestershire, GL5 4EP
www.amberley-books.com

Copyright © Stephen Butt, 2018
Map contains Ordnance Survey data
© Crown copyright and database right
[2018]

The right of Stephen Butt to be
identified as the Author of this work
has been asserted in accordance with
the Copyrights, Designs and Patents
Act 1988.

ISBN 978 1 4456 7815 3 (print)
ISBN 978 1 4456 7816 0 (ebook)

British Library Cataloguing in
Publication Data.
A catalogue record for this book is
available from the British Library.

Origination by Amberley Publishing.
Printed in Great Britain.

INTRODUCTION

The story of Weston-super-Mare is a brief chapter in the history of England. When Francis Knight wrote *The Seaboard of Mendip* at the beginning of the twentieth century, there were men and women who could remember the fishermen who had worked from Weston Bay and kept donkeys to haul their catch along the beach. Knight called Weston 'a town without a history'.

When John Collinson's antiquarian history of Somerset was published in 1791, he described this coastline as 'a flat sandy strand, two miles in length to Anchor-head, at the west end of Worle-hill, which is another vast rocky eminence, and a remarkable object by sea and land'. Where Weston-super-Mare now thrives, there was little except a small cluster of cottages nestling in the shelter of the hill, and in the shadow of the parish church, looking out across the sand, dunes and sea.

It is partly the stone of Weston – solid grey limestone hewn from the quarry below Worlebury – that gives the town a sense of permanence and longevity, but the greatest influence on the town's architectural heritage was the remarkable architect Hans Fowler Price. Born in Bristol, Price studied in Liverpool and then made Weston his home, establishing his own architectural practice when still in his twenties.

Price was wealthy enough to afford foreign holidays, which he used to widen his knowledge of architectural styles. He brought these back to Weston, incorporating Gothic, Classical, Moorish, Flemish, Baroque, Elizabethan and Jacobean styles in his designs, which were practical but pleasing, appropriate in their context and often exciting. Despite his mixing and matching of styles, his buildings always look 'right'. He was a master of his craft who would never allow his exuberance to run out

of control. His dominance of the landscape of the town means that any history tour of Weston will be a celebration of his work.

Why did Weston grow so dramatically during the nineteenth century? It was certainly due to the technological advances of the Victorian age, which enabled the railways to connect the industrial inland towns with the coast. It was also due to the social enlightenment that was to make the invigorating air of the seaside available to the masses who worked in factories, as well as to the elite.

Locally, there was the matter of the management and ownership of land. The Pigott family of Brockley acquired the manor of Weston in 1696 and held it until the outbreak of the First World War. In 1808 the Pigotts sold off the ancient Auster tenements (the old huts of the fishermen and their plots of land), which paved the way for the Weston Enclosure Act of 1815. Two men bought much of the Auster property, Richard Parsley and William Cox, the first of a line of entrepreneurs who were to greatly influence the future of the town.

My grandfather was Henry Butt, but not *the* Henry Butt, who was Weston's first mayor and one of the great characters of the town's past. Grandfather did bump into his namesake once in High Street. The exact dialogue has been lost in the mists of time but followed the lines of:

'Do you know who I am, my man?'

'No?'

'I am Henry Butt.'

'Well, so am I. Pleased to meet you.'

My grandfather shook the mayor's hand and they parted, one with slightly less wind in his sails.

My great-grandfather on my mother's side, Revd Alexander John Woodforde, served briefly as a curate at the Parish Church of St John, at which time he lived at Chittagong Villa in Shrubbery Walk. He was later the vicar of Locking. He painted watercolours of Locking Church and vicarage, but no paintings by him of Weston have come to light.

My earliest knowledge of the town's history came from his son, my grandfather, Reginald Woodforde, who would take me on long walks during school holidays, accompanied by his Border collie, along the promenade and through Worlebury, telling me his own version of the past – always entertaining, but somewhat fictional at times.

Between school and university, I wrote local history articles for a short-lived Weston-based free sheet, an invaluable few months when I was taught by a former Fleet Street editor how to write and research. One memorable assignment was to interview Mr William Badman, who delivered the wet-cell batteries to Guglielmo Marconi that powered the history radio transmission from Brean Down on 18 May 1897. He was later to become the proprietor of Radio Relay, the little shop in Orchard Street where those same batteries were charged.

No one historian writes the complete history of any place, time or subject. We all make use of, and must acknowledge, the work of contemporaries and those who have gone before. The antiquarian histories, including John Collinson's *History and Antiquities of the County of Somerset* (1791) and Francis A. Knight's *The Seaboard of Mendip* (1902), provide the historical backdrop to this tour, together with the work of more recent local historians published by the Weston-super-Mare and District Family History Society, and articles in the *Weston Mercury* by authoritative historians such as John Bailey, whose 'Round About Somerset' articles are still a vital source for anyone exploring the past.

Pictorially, we must depend upon photography for the record of Weston's past, the commercial photographers of the Victorian and Edwardian age, and the gifted amateur photographers of later decades when lightweight cameras and relatively inexpensive film came onto the market. The images in this book record both change and the fact that some buildings and locations seem never to change. The photograph of Waterloo Hall is by Neil Owen and the image of the Blakehay Theatre is by Julian Osley. The copyright and ownership of both are recognised and acknowledged.

KEY

1. *Weston Mercury* Offices
2. Waterloo Hall
3. The Boulevard
4. Lance and Lance Department Store
5. Town Square
6. Sovereign Centre and Old Post Office
7. Winter Gardens and Pavilion
8. Blakehay Theatre
9. Grove Park Bandstand
10. Grove Park
11. St John's Parish Church
12. Weston Technical College
13. Thatched Cottage Restaurant
14. The Promenade
15. Flat Holm
16. Marine Lake
17. Knightstone Island and Causeway
18. Knightstone Former Pavilion and Theatre
19. Knightstone Former Baths
20. Dr Fox's Baths
21. St Nicholas' Church, Uphill
22. Madeira Cove
23. Anchor Head
24. Birnbeck Pier
25. Kewstoke Toll Road
26. Prince Consort Gardens
27. Rozel Bandstand and the Cove
28. Ernest MacFarlane Fountain
29. Grand Pier
30. Princess Royal Square and Grand Central Hotel
31. Former Bus Station
32. Grand Atlantic Hotel
33. The Tropicana
34. Huntley's Hotel
35. Regent Street
36. Big Lamp Corner
37. High Street
38. Meadow Street
39. The Plantation
40. Railway Station
41. Old Signal Box
42. Floral Clock
43. The Odeon
44. The Town Hall
45. Former Police Station and Magistrates' Court
46. Victoria Methodist Church
47. Walliscote Board Schools
48. Ellenborough Crescent and Parks
49. Clarence Park
50. Radio Relay
51. Weston Museum
52. Former Queen Alexandra Memorial Hospital
53. Former Town Library and Museum

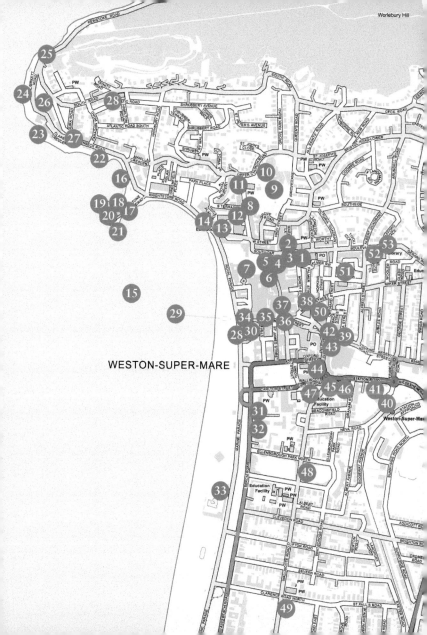

1. *WESTON MERCURY* OFFICES, NO. 32 WATERLOO STREET

Designed by Hans Price and completed in 1874, this was one of the last buildings designed by Price to be constructed along the Boulevard. Its design links the frontages of the Boulevard with the narrower Waterloo Street using a quadrant (curved feature) and a dramatic four-stage tower to deceive the eye. It has a special silhouette that increases its importance as a heritage building. Price worked in many styles, in this case Dutch Baroque with a Spanish influence in the tower. The building was acquired by the *Weston Mercury and Somersetshire Herald* in 1885.

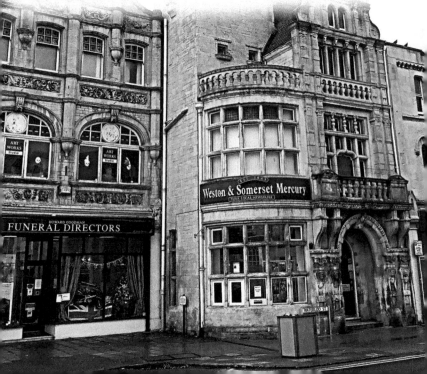

2. WATERLOO HALL

Waterloo Hall was also designed by Hans Price, and built by the local firm of Stradling & Sons for the Plymouth Brethren. It took six months to construct at a cost of £1,000 and opened on Thursday 18 October 1877 when three celebratory services were held. As an evangelical Christian and teetotaller, Price's personal beliefs would have been in accord with those of the Brethren. In the 1950s, a plan to extend the Boulevard to the seafront – later abandoned – threatened the hall with demolition. Haile Selassie, Emperor of Ethiopia from 1930 until 1974, worshipped here during the war years after the invasion of his country forced him into exile in England.

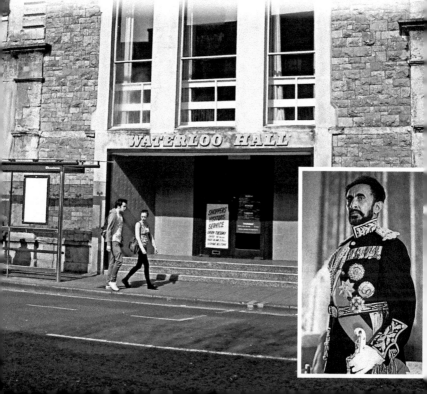

3. THE BOULEVARD

The Boulevard was laid out in 1855, the land bequeathed to the town by the then lord of the manor John Hugh Smyth-Pigott. Waterloo House, built in 1815, the year of the battle, was partly demolished to make way for this wide tree-lined development aligned to the spire of the then relatively new Christ Church at Montpelier. Over eleven years, Hans Price built most of the Boulevard, including his own offices at No. 28, the Church Institute and the Masonic Lodge of St Kew (now the Constitutional Club).

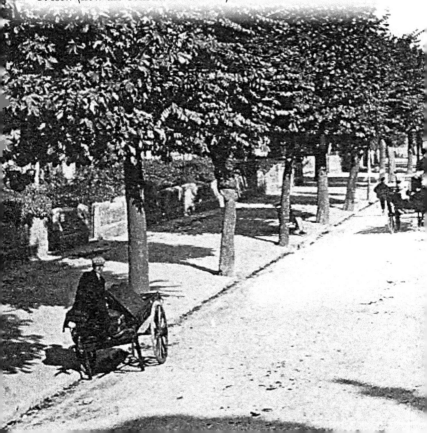

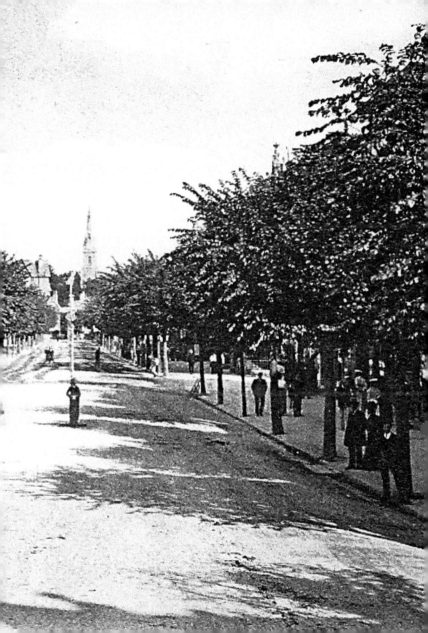

4. LANCE AND LANCE DEPARTMENT STORE

This popular department store was destroyed by enemy bombing in June 1942, but such was the store's fine reputation that the site is still known as Lance's Corner. More than 100 people died in the three-night Blitz, and 3,000 were made homeless. In 1933, the store was an early acquisition of the John Lewis Partnership. It is possible that John Spedan Lewis visited while recuperating in Weston after a serious riding accident in 1909 and was impressed by the service he received as a customer.

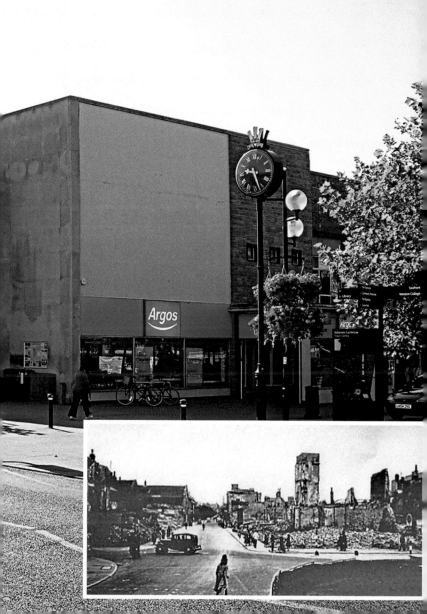

5. TOWN SQUARE

The land was presented to the town by Henry Butt, Weston's most famous mayor, partly in recompense for damage caused to the town's roads by his heavy vehicles transporting stone from his quarries. A shrewd businessman with a tendency to be self-opiniated, Butt changed the face of Weston but also gave generously. The square underwent major refurbishment in 2017, including the installation of a water feature.

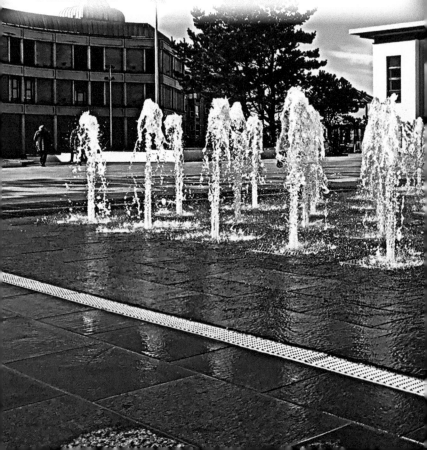

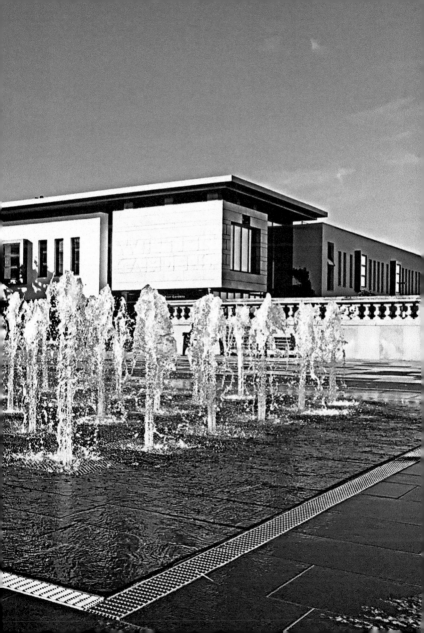

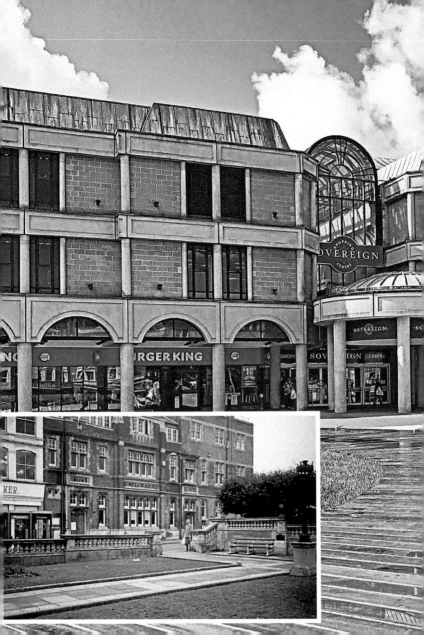

6. SOVEREIGN CENTRE AND OLD POST OFFICE

Weston's first and main shopping centre was built on part of the Winter Gardens and completed in 1992. The development meant the demolition of the General Post Office, which stood on the southern side of the Town Square. It had been built in 1899 on the site of the former Veranda House. The Royal Arcade, home to many small independent shops, ran behind the buildings that face the High Street.

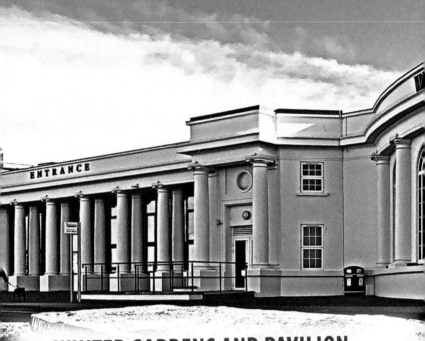

7. WINTER GARDENS AND PAVILION

Connecting the town to the seafront, the Winter Gardens were completed in 1927 with extensive gardens, tennis courts and putting greens. They were built on land known as Roger's Field, which the Urban District Council acquired by compulsory purchase to create an 'Old English Garden'. Henry Butt provided the funds, which amounted to £2,640. The architect was the internationally recognised Lancastrian Thomas Hayton Mawson. In the 1960s Saturday night dances, beauty contests, Christmas parties for children of employees of Westland Aircraft, and the annual Junior Arts Festival were held here. Half a century on, the Winter Gardens' popularity began to wane. After operating at a loss for several decades, the venue has been extensively refurbished and is now part of the campus of Weston College.

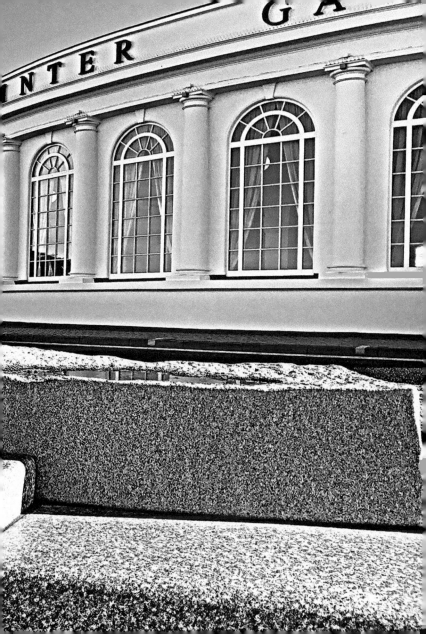

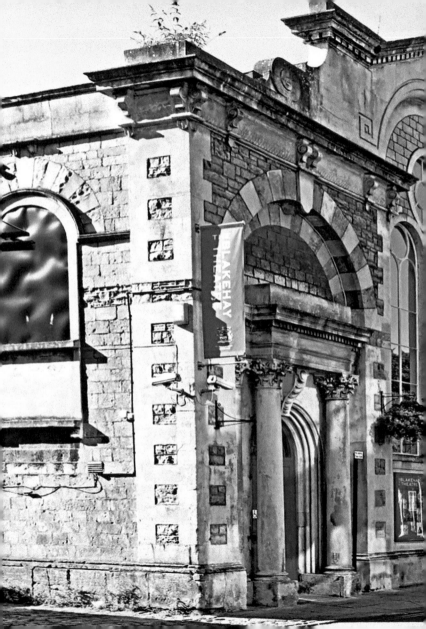

8. BLAKEHAY THEATRE, WADHAM STREET

This was the town's first Baptist church, built in 1850 and enlarged by Hans Price in 1862 as one of his earliest commissions. It was rebuilt again after being damaged by incendiaries during the Second World War. In 1986, it was saved from demolition by the Weston-super-Mare Building Trust and purchased by the town council in 2004 for £194,000. Its new name is derived from 'Black Hay', a field that lay between the High Street and Wadham Street.

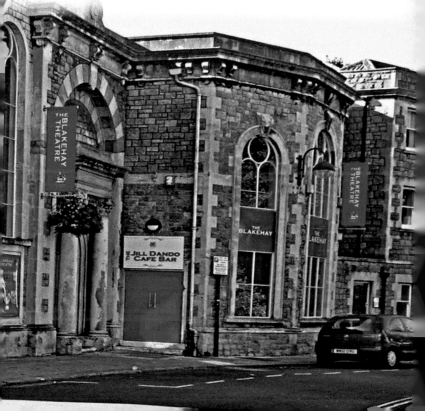

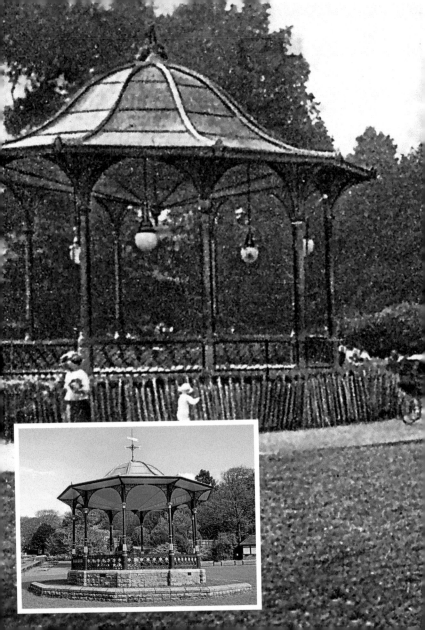

9. GROVE PARK BANDSTAND

This Grade II-listed bandstand was built in 1890–91 by Hill Bros, the ironwork being forged at their Sun Foundry in Alloa. The design and construction were supervised by the then town surveyor A. E. Collins as part of the conversion of the area from private pleasure grounds into a public park. It was dismantled and completely restored in 2014 at a cost of £100,000, and is now frequently used for musical entertainment during the summer.

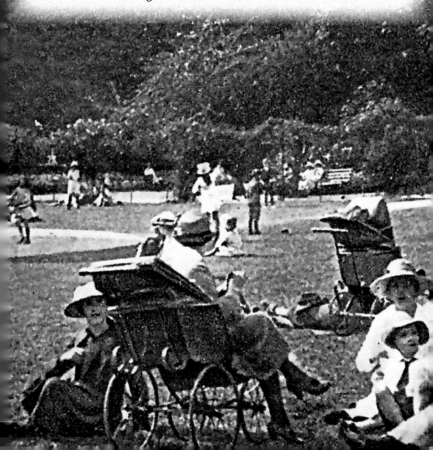

10. GROVE PARK

Grove Park was part of the private gardens of the Smyth-Piggott family in the eighteenth and nineteenth centuries. Needing to raise finance, Cecil Hugh Smyth-Piggott offered the land for development in 1889. It was secured for the public by the Town Corporation on payment of an annual rent of £900, and in 1890 a government loan of £2,000 enabled it to be laid it out as a public park, the hillside location being ideal for waterfalls and other features. In a secluded corner is Jill's Garden, in memory of the television presenter Jill Dando, who was born in Weston.

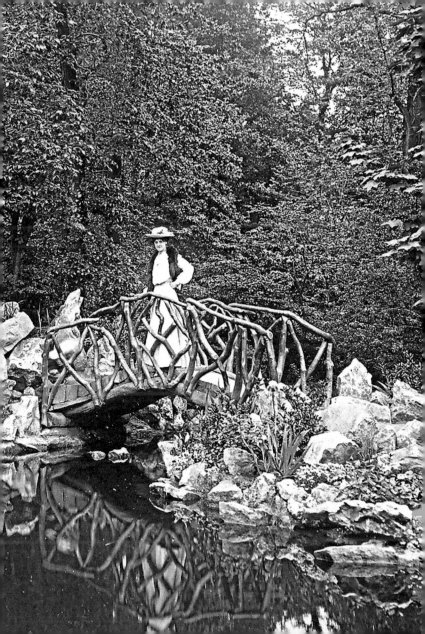

11. ST JOHN'S PARISH CHURCH

There has been a church on this site for at least 700 years, but this a more recent building. The nave dates from 1824, and the chancel and aisles were added over the following four decades. The east window is of national significance. Thought to have been a gift from Bishop George Henry Law, who was Bishop of Bath and Wells (1824–45), it is the work of Thomas Willement, armorial painter to George IV and stained-glass artist to Queen Victoria. The glass was shattered in an air raid during Second World War and restored in 1949.

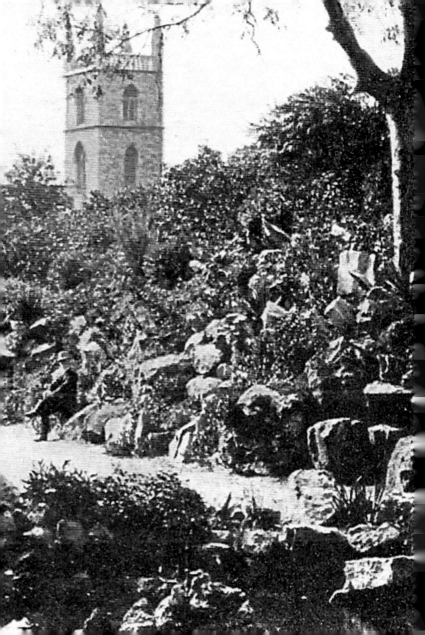

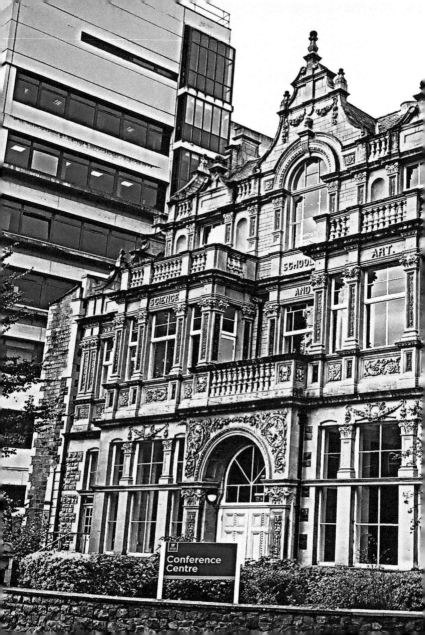

12. WESTON TECHNICAL COLLEGE, LOWER CHURCH ROAD

Perhaps the finest example of Hans Price's work – exuberant but also practical. It was opened in 1893 as the School of Science and Art following educational reforms by Sir Henry Cole that promoted the teaching of qualifications to encourage a new generation of skilled technicians and designers. The building separated science and art on different floors, with larger windows providing more light in the rooms used by the artists. It was refurbished between 1997 and 2012 and is now the college's conference centre.

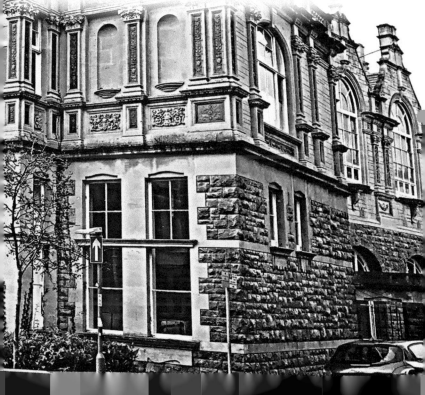

13. THATCHED COTTAGE RESTAURANT, KNIGHTSTONE ROAD

Probably built in 1791, this is thought to be Weston's oldest building, and is Grade II listed. The bay window has its original casements. It is the remaining section of a much larger house constructed by the wealthy Revd William Leeves as his holiday home. From 1779 he was the rector of Wrington in Somerset until his death there in 1828. He was also a composer of sacred music, but is most well known for the secular air for 'Auld Robin Gray', written by the Scottish poet Lady Anne Lindsay in 1772.

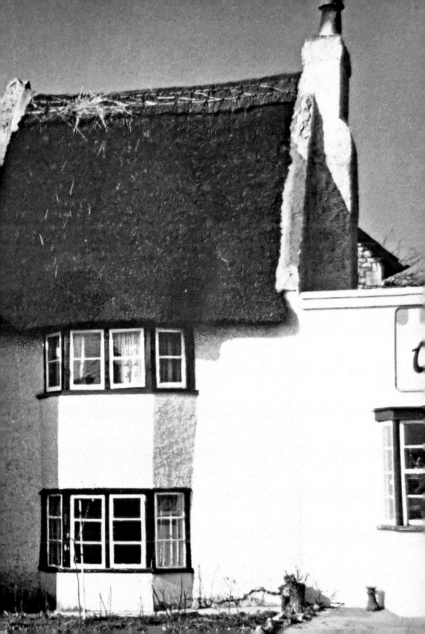

14. THE PROMENADE

One of Weston's finest assets as a holiday resort, the broad sweeping promenade and sea wall were built in 1887 and imaginatively renewed in 2010 as part of the town's new flood-defence project. The comedian and entertainer Bob Hope (1903–2003), who appeared in more than seventy films, lived in Orchard Street and Southend Road for a short time when he was a baby while his father was working as a stonemason on the sea wall. The promenade took major gale damage in the storm on Sunday 13 December 1981.

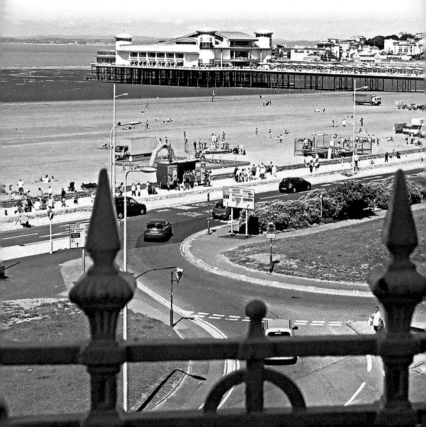

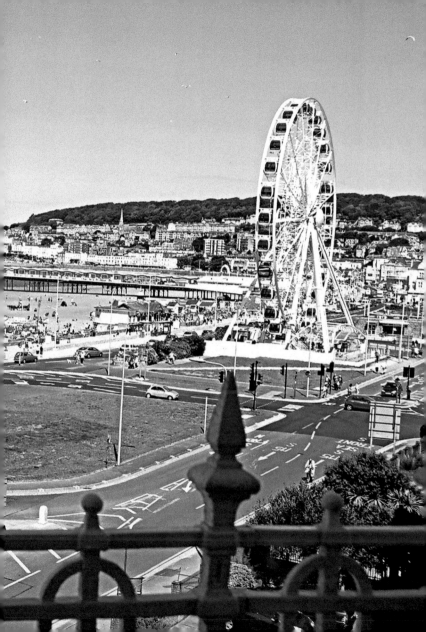

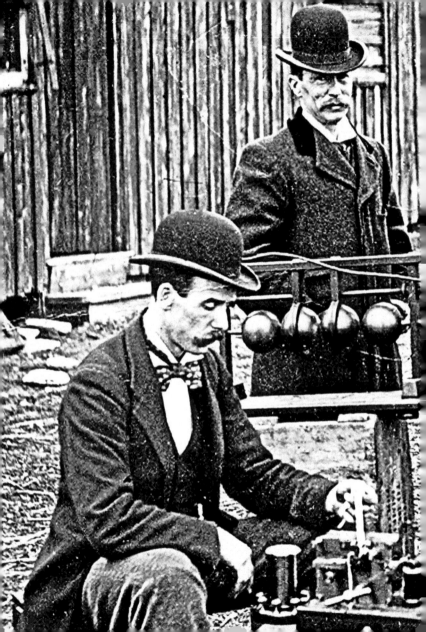

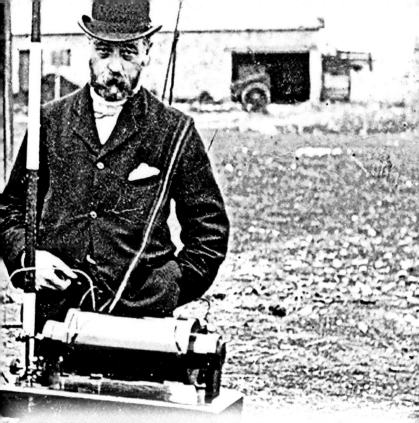

15. FLAT HOLM

Looking out to sea on all but very misty days, Flat Holm and its lighthouse can be seen 6.6 miles offshore. This small limestone island is part of the city of Cardiff. It has a long history of habitation going back to the disciples of St Cadoc in the sixth century AD. The lighthouse was constructed in 1737. Guglielmo Marconi transmitted the first wireless signal over water from here to Lavernock Point on the Welsh coast in 1897. His later experiment was from Brean Down, south of Weston-super-Mare.

16. MARINE LAKE

The Marine Lake was created in Glentworth Bay in 1929 when the causeway was built, linking the headland just south of Anchor Head with Knightstone. In its heyday this was a 'resort within a resort', with family entertainment and food provision in a safe and comfortable environment. A concrete extension at promenade level was later added, which was damaged beyond repair by the storm of 1981.

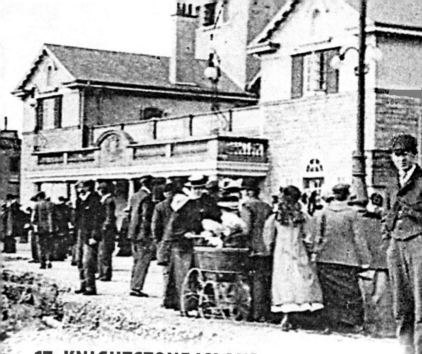

17. KNIGHTSTONE ISLAND AND CAUSEWAY

A guidebook of 1822 speaks of Knightstone being 'joined to the village by a bank of pebbles thrown up by the sea'. In the great gale of 10 September 1903, little more than a year after the opening of the Knightstone Pavilion, the bank was washed away. At least three different eras of repairs can be seen in the sea walls near the jetty. The small harbour was where the first vessels to visit the town and to work out of Weston were moored. A devastating fire on the island in 1844 prompted the setting up of Weston's first fire brigade. Weston's famous winter carnivals traditionally assembled here before parading through the town.

18. KNIGHTSTONE FORMER PAVILION AND THEATRE

The Pavilion opened in 1902, designed and built by the London architect J. S. Stewart. It was a fine example of a multipurpose hall capable of providing for a wide range of holiday entertainments. Its name was changed to the Knightstone Theatre when the Winter Gardens Pavilion opened in 1927. During the Second World War it was commandeered as a battledress factory, reopening in 1942. The theatre closed in 1991 and, after several years of planning indecision, was converted, with the adjacent baths, into apartments in a project costing £20 million.

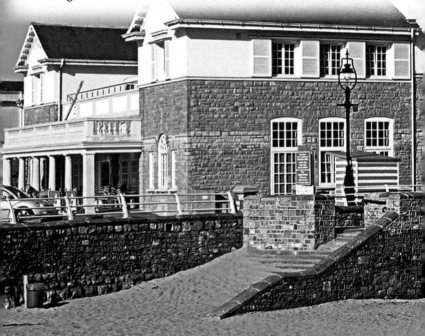

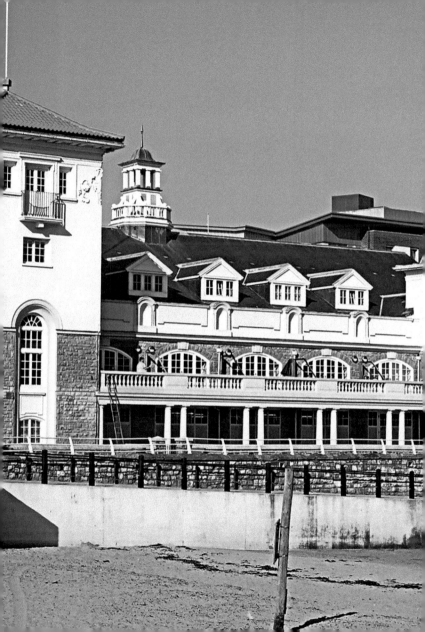

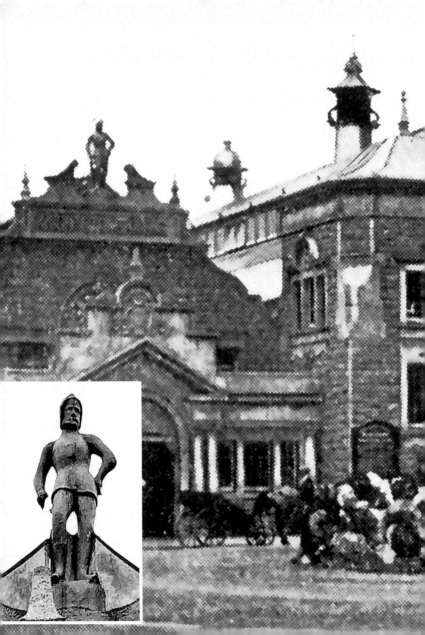

19. KNIGHTSTONE FORMER BATHS

The first bath house and pool at Knightstone opened in 1822, offering hot and cold facilities with alleged medicinal benefits. It is thought these were destroyed in the 1844 fire. The Edwardian baths, a listed building and now part of an apartment complex, were built in 1902. The legend that Knightstone was the burial place of an ancient knight whose bones were reportedly found during the island's first development is represented in the statue on the crest of the building's roof.

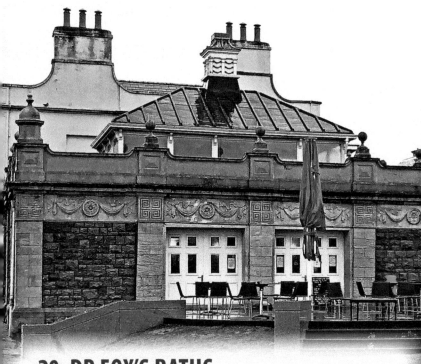

20. DR FOX'S BATHS

The remarkable Dr Edward Long Fox was a pioneer in the treatment of mental illness and established an asylum at Brislington House, near Bristol, where his compassionate approach was practised. He purchased Knightstone in 1832 and built new baths to further his medical work. He also reinforced the island's sea defences and the causeway, importing the stone from his family's quarries in his native Cornwall. The ground floor of his bath house is now occupied by tearooms. The latest residential developments incorporated all three of the island's listed buildings and created a perimeter walkway.

TO THE
GLORY OF GOD
IN
GRATEFUL TRIBUTE
TO
OUR BROTHERS
OF THIS PARISH
WHO GAVE
THEIR LIVES FOR
THEIR COUNTRY
IN THE GREAT WAR
1914–1918

21. ST NICHOLAS' CHURCH, UPHILL

Looking south along the promenade, the Mendip Hills meet the Bristol Channel at Uphill and Brean Down. Steep Holm, the second island in the Bristol Channel, is part of the geological feature. Perched high above Uphill village is the old, and now partly ruinous, Church of St Nicholas, which dates to around 1080 and was built on the site of two even earlier places of worship. This was possibly a pilgrim route from the harbour at Uphill to Glastonbury Abbey. The nearby round tower was formerly a windmill dating to the eighteenth century.

22. MADEIRA COVE

Good use of the natural landscape was made here to create a succession of paths, gardens and shelters overlooking Glentworth Bay, from which the entire length of Weston's bay across to Uphill could be seen – a place for promenading and 'taking the air'. A renovation project began in 2010, which included the planting of species of maritime plants, reflecting the natural flora of the area.

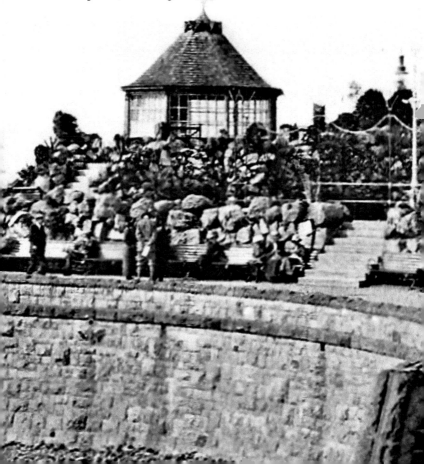

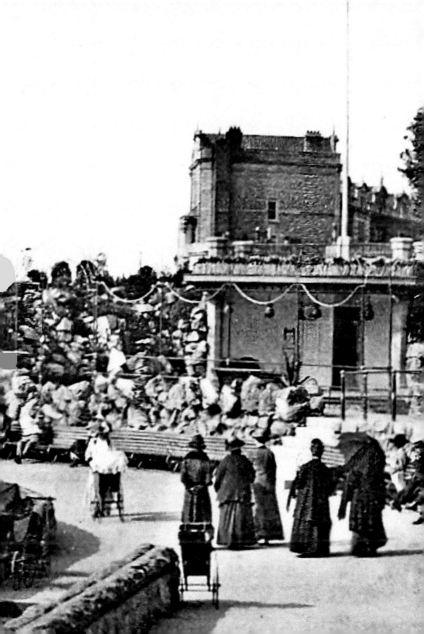

23. ANCHOR HEAD

Long before Weston became a seaside resort, the sea crashed onto these rocks at high tide. The drama became an inviting spectacle, so the Victorian engineers made it more accessible – even for ladies in long skirts! In 1791, the Revd John Collinson wrote in his history of Somerset: 'northward from Uphill is flat sandy strand two miles in length to Anchor-head, at the west end of Worle-hill, which is a ... vast rocky eminence, and a remarkable object by sea and land.'

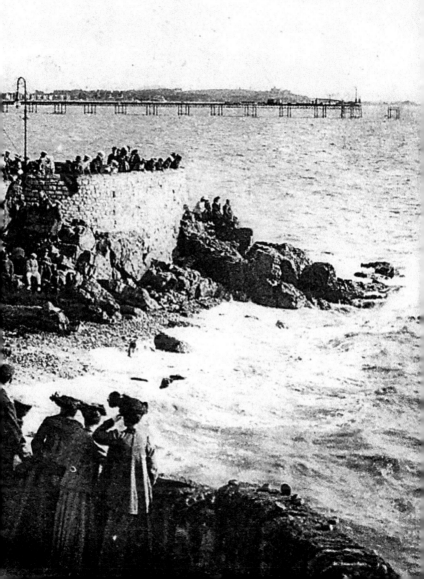

24. BIRNBECK PIER

One of no less than fourteen piers engineered by Eugenius Birch, Birnbeck Pier was opened on 6 June 1867. It is the only pier in the country to link the mainland with an island. Hans Price designed the pier head buildings. The original structures on the island were destroyed in a fire in 1897. Since the 1970s, the pier has fallen into disrepair, despite the strenuous efforts of campaigners who still intend to rescue it from total collapse.

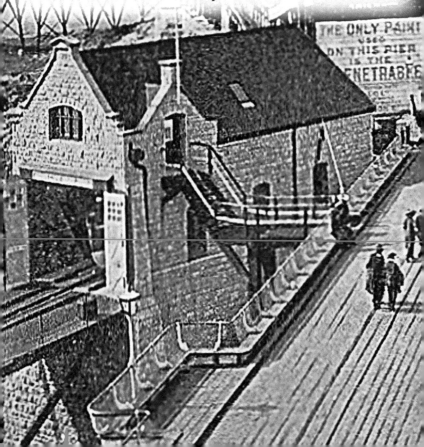

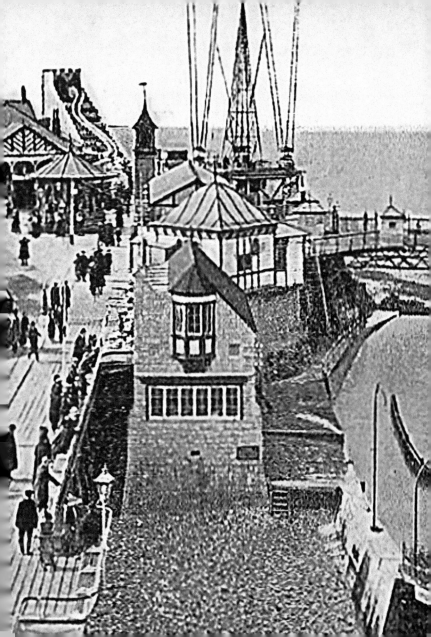

25. KEWSTOKE TOLL ROAD

Arthur Mee wrote 'the finest thing that Weston has ... is the drive to Kewstoke through the woods.' This meandering road around the edge of Worlebury Hill, connecting Weston with Kewstoke, was part of the former Smyth-Pigott estate, so retained the status of a private road on which a toll could be levied. The toll gate opened in 1848. Tolls ceased in 2004, and safety measures were put in place following several serious road traffic accidents.

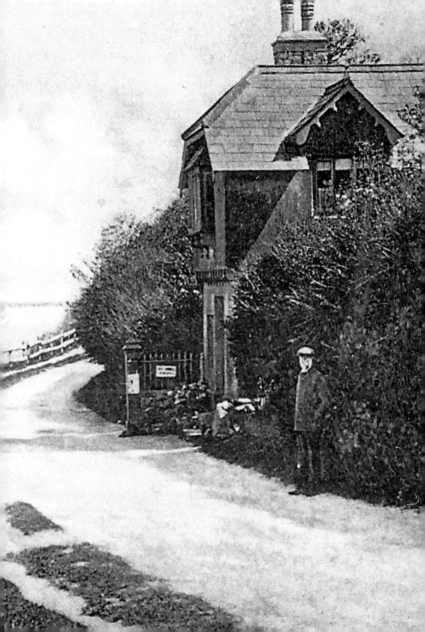

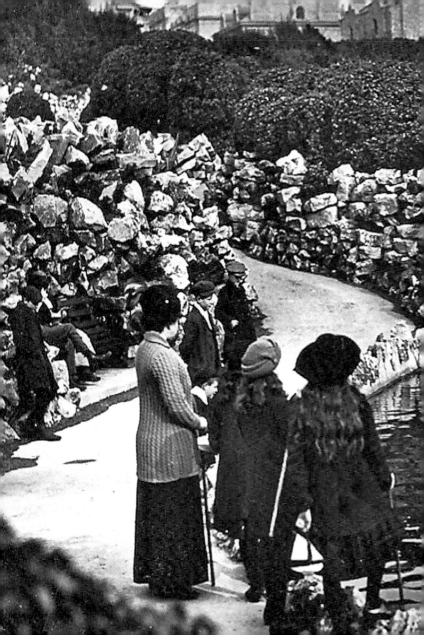

26. PRINCE CONSORT GARDENS

Originally a bare and windswept hillside known as Flagstaff Hill, the land was owned and laid out by the Smyth-Pigott family. In 1862, Cecil Hugh Smyth-Pigott responded to local people trespassing on his property by fencing in the gardens and charging an admission fee. However, in 1867 it was presented to the town and renamed in memory of Prince Albert. The flagstaff was situated on the lower triangle (now a car park) and was sometimes used to warn coastguards of smuggling activity off the coast. The gardens are now maintained by a group of volunteers, who have replanted borders and in 2018 secured funding to restore the pond. The view across the Bristol Channel is one of the finest in the area.

27. ROZEL BANDSTAND AND THE COVE

The promenade leading north-west towards Anchor Head gradually developed into a small-scale 'pleasure park' to suit the Edwardian taste for music and entertainment. The 'Dutch Oven' bandstand was built on the edge, with an open seating area opposite. Later, tucked into the raised area nearer the road, was the small Cove Theatre, where family shows were staged until the 1960s and which later accommodated a model railway exhibition. In 1937, the Rozel Bandstand was built where for many years jazz musician Vernon Adcock and his band entertained tourists.

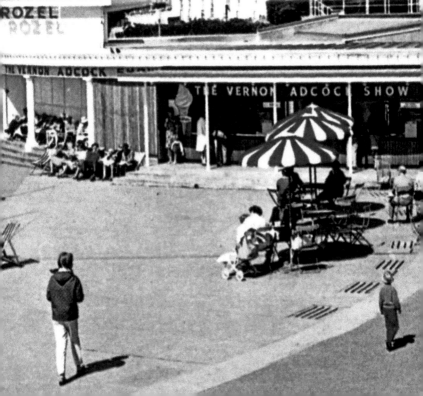

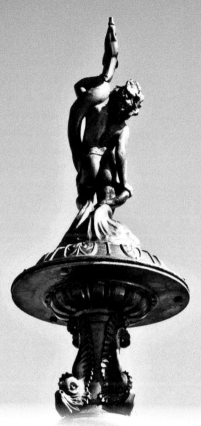

28. ERNEST MACFARLANE FOUNTAIN

The lawns opposite the Grand Pier – now the Princess Royal Square –
were first landscaped in 1910, but remained without a centrepiece
until 1913 when Thomas Ernest Macfarlane, chairman of the Urban
District Council, donated the Coalbrookdale Fountain, more popularly
referred to as the 'Boy and Serpent'. The fountain was restored in
2011 when it was switched on by Thomas's great-granddaughter,
Mary Macfarlane.

29. GRAND PIER

Work began on the construction of the Grand Pier on 7 November 1903. It opened in the following June. At the end was a 2,000-seat theatre, used as a music hall and for staging plays, ballet and opera. In 1907, a 1,400-foot extension was built, to be used by passenger vessels from Cardiff, but strong currents made this impossible and it was demolished. The theatre was destroyed by fire on 13 January 1930. A new owner rebuilt it three years later to house a funfair. On 28 July 2008 another fire broke out, which destroyed the pavilion. It was rebuilt again and reopened on 23 October 2010.

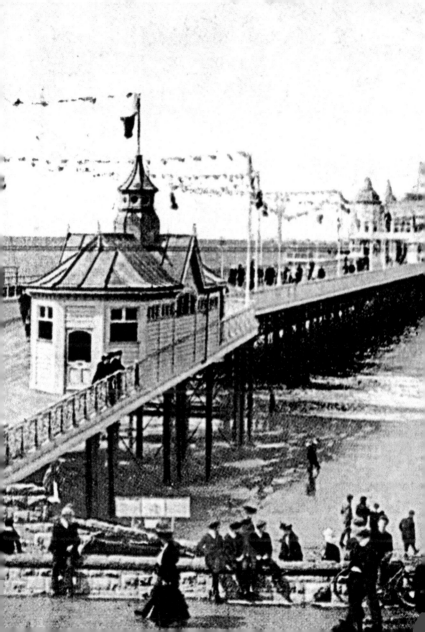

30. PRINCESS ROYAL SQUARE AND GRAND CENTRAL HOTEL

Thomas Ernest MacFarlane was also the owner of the Grand Central Hotel, facing seawards across what was formerly Pier Square. At night, the lighting columns in the square were designed to spell the word 'pier' in Morse code. The area was renamed after and reopened by Her Royal Highness the Princess Royal on 25 July 2011.

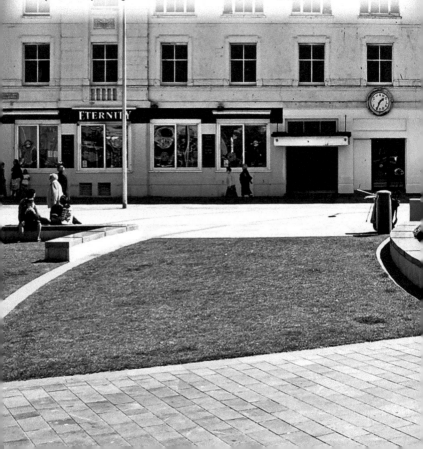

31. FORMER BUS STATION

The seafront bus station was constructed in 1928 on the site of the former Belvedere Mansion, and enabled passengers from Bristol to step straight out onto the Beach Road. The Bristol Omnibus Co. began with tramway services in Bristol in 1875. Its smart green buses were familiar to all in the latter half of the twentieth century, with cream-coloured open-top double-deckers on the seafront route.

32. GRAND ATLANTIC HOTEL

Originally a school known as 'The College', the building was enlarged and renovated, reopening in 1888 as the Grand Atlantic Hotel. For over a century this solid stone-built example of Victorian elegance, which has echoes of a French chateau, dominated the seafront until the adjacent modern apartment development began to detract from its impressive setting.

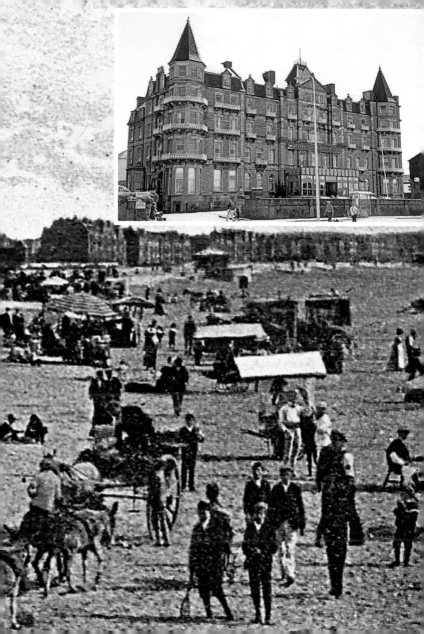

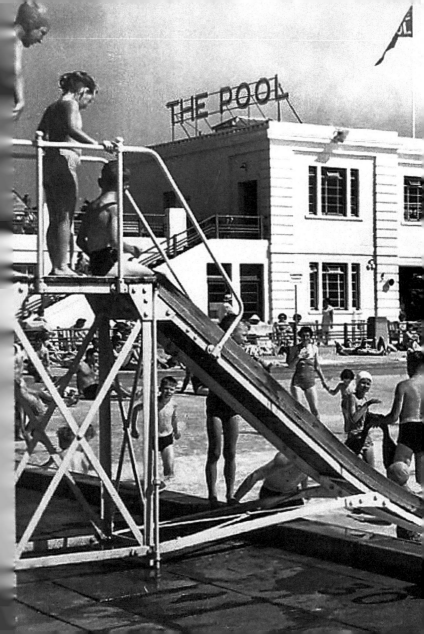

33. THE TROPICANA

Known worldwide as the location of the street artist Banksy's remarkable *Dismaland* project staged in the summer of 2015, the Tropicana was built as 'The Pool' in 1937. At the time it was the largest open-air swimming pool in Europe. The reinforced-concrete art deco diving board was removed in 1982 before the amenity was renamed the Tropicana. The centre closed in 2000 and lay empty for fifteen years until the Banksy event, which attracted almost 200,000 visitors – more than the entire population of North Somerset – breathed new life into the town.

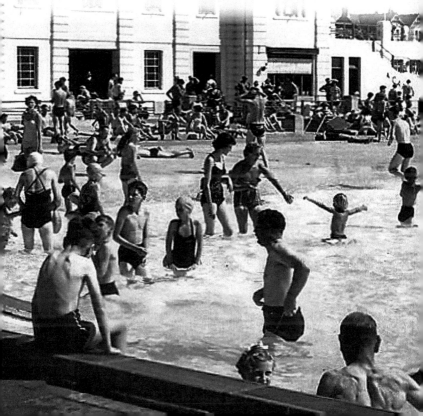

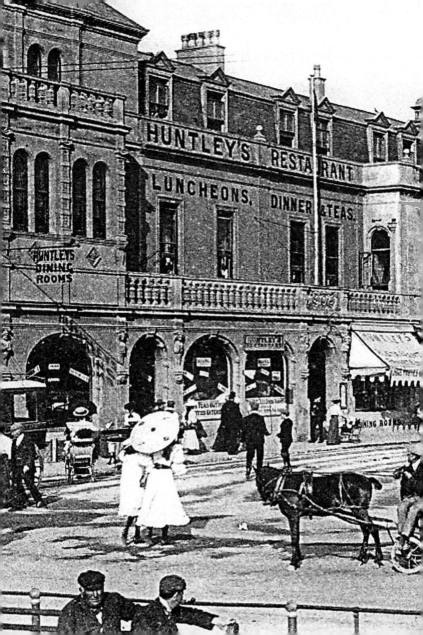

34. HUNTLEY'S HOTEL

On what is probably the busiest location on Weston's seafront, at the end of Regent Street and opposite the Grand Pier, Herbert and Selena Huntley, members of Victoria Methodist Church near the Town Hall, built their hotel and beach café. Part of the building was formerly Joseph Whereat's Reading Rooms, built in 1826. Here, Whereat offered a stamp office, public library, and reading room. He was also a printer, and sold foreign fancy merchandise and patent medicines.

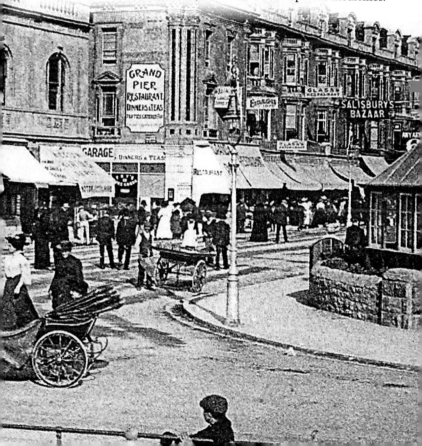

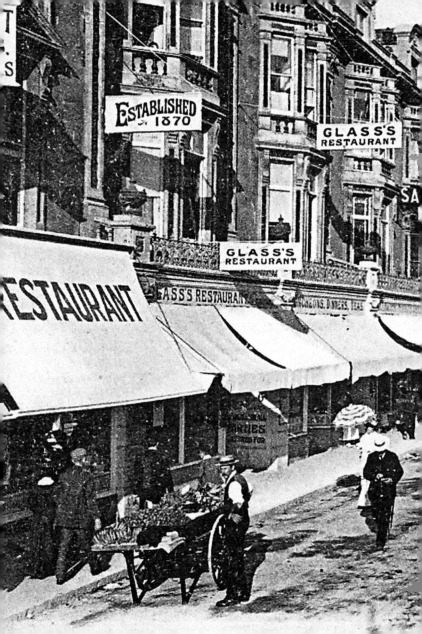

35. REGENT STREET

When Weston was still a fishing village, Regent Street marked its southern boundary. When the railways arrived, it was the shortest route from the station to the beach. After the advent of the family motorcar, it evolved into a principal road route, being the extension of Locking Road, the main route from Bristol. Here, a host of seaside shops, cafés and amusement arcades sprang up. The proximity of the Sovereign Centre and the new Dolphin Centre reinforces this thoroughfare's importance in connecting the town's shops with the seafront.

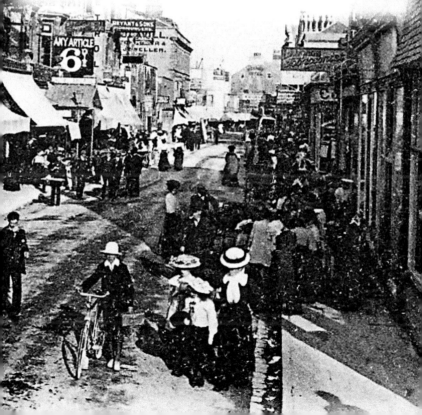

36. BIG LAMP CORNER

The 'Big Lamp' corner is known to all Westonians as the junction of High Street, Meadow Street and Regent Street, where for many years a policeman on point duty controlled the traffic. This was once the site of the village green, and the spot where the HSBC bank now stands was known as 'Gossip Corner'.

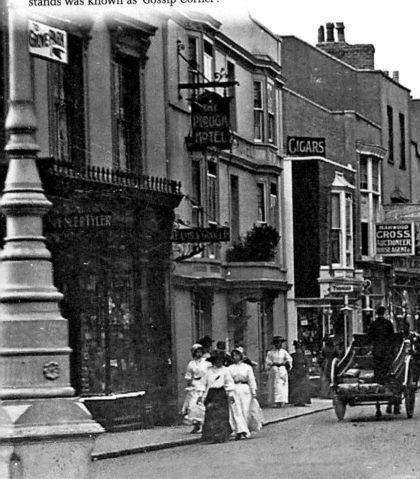

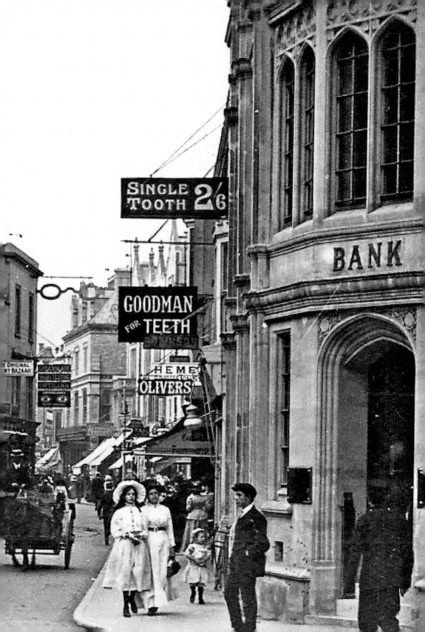

37. HIGH STREET

One of the town's oldest streets, High Street has served as Weston's major shopping area for at least 150 years. F. W. Woolworth, successor to Felix Thomas's ironmongery shop, was dominant, occupying a former Nonconformist church of 1858 in the heart of the street. Nearby there were famous local and national brands including Butters, Walker & Ling, Lances, Carwardine, Boots, Littlewoods, Marks & Spencer, Timothy Whites, Currys, Dixons and Coulstings. Possibly the most familiar landmark was the clock outside John Rossiter's jewellery shop. The business was founded in 1832, and is still operating at the same address with the fifth, sixth and seventh generations of the family.

38. MEADOW STREET

Local independent traders have always occupied Meadow Street, which now forms the axis of 'Orchard Meadows', the affectionate name given to the network of little streets in the area. Older residents will remember the leather goods shop owned by brothers Cecil and Sydney Louch, and generations of school children were kitted out with school uniforms bought at William Burrow and W. T. Salisbury. National retailers included Liptons and David Greig, who were later to amalgamate with Maypole and Home and Colonial, whose shops were nearby in High Street.

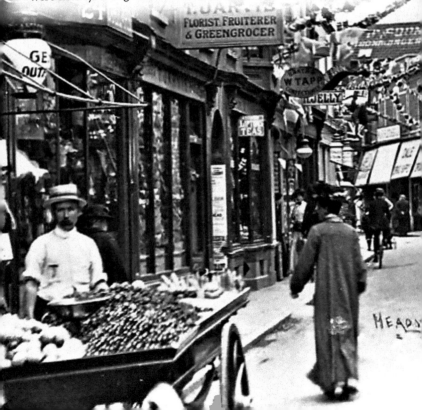

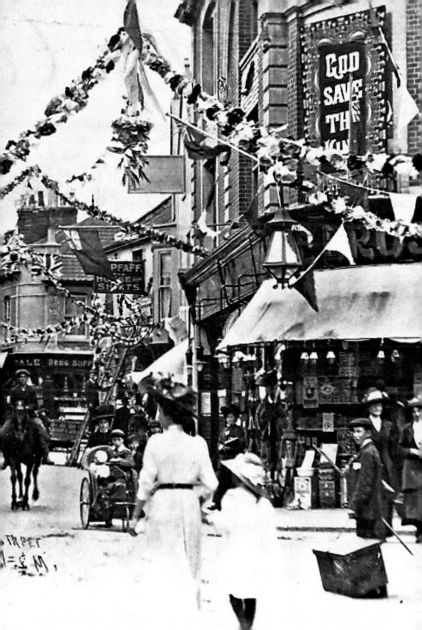

39. THE PLANTATION

The centre of Weston has been served by four railway stations. Locking Road, opposite the Odeon cinema, was the site of the first station, which opened on 14 June 1841. The line linked to the main Bristol to Exeter route around 1.5 miles away, and at first, the trains were horse drawn. A replica of *North Star*, the first steam locomotive to be used on the line, was unveiled in 2006 to mark the 200th anniversary of the birth of Isambard Kingdom Brunel, who designed the first station. Brunel and his family lived at Swiss Villa in Trevelyan Road while the line was being constructed. In 1871 the site was gifted to the Weston Improvement Commissioners and planted with trees – hence 'the plantation'. For many years it was also known as Old Station Square and, more recently, Alexandra Parade. The present traffic system and pedestrian crossings were created in 1964.

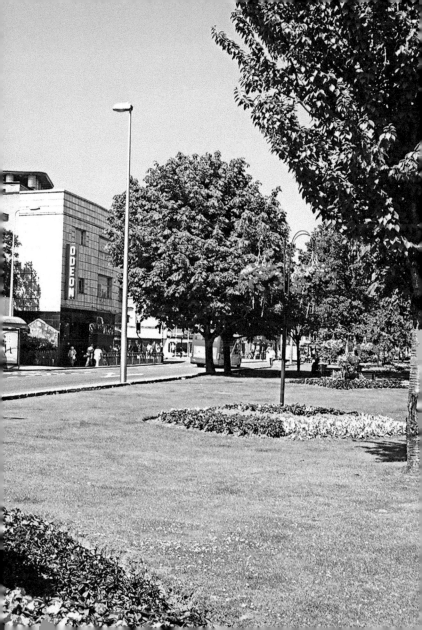

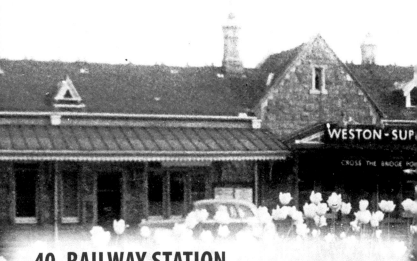

40. RAILWAY STATION

In 1841, new tracks were laid, connecting to the main line in the Bristol direction at a junction near Worle. A short section of the old track remained to transport coal to the gasworks, with a level crossing over Drove Road. Today's Winterstoke Road follows the route of the old track, and was known locally as Gasworks Lane. In 1866 a new station was built where the Tesco supermarket now stands. The present through station, with curved platforms and the completion of the loop in the Taunton direction, opened on 1 March 1884. In 1914, a further terminus opened on the site of the 1866 station for holiday excursions at peak times. This closed in 1964 and the loop line was reduced to single-track operation in 1972. The present station is Grade II listed.

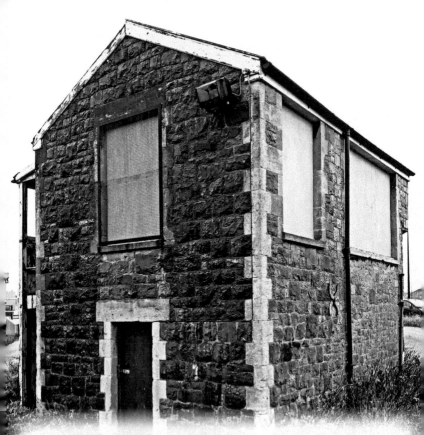

41. OLD SIGNAL BOX

This often overlooked little building was constructed in around 1866 and is said to be the oldest surviving signal box in the UK. It was built by the Bristol & Exeter Railway. It was replaced by a larger box when the present station and running tracks were built in 1884. One corner was chamfered at some time to make space for a new siding, and there are signs that it was extended early in its life. A modest but important part of local railway history.

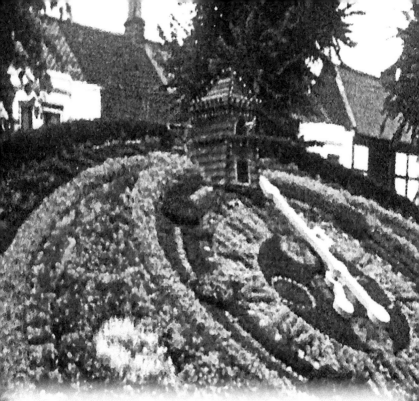

42. FLORAL CLOCK

Floral clocks were once a popular feature of municipal gardens. Weston's clock was built in 1935 in the heyday of these ornamental features, and the same year in which the Odeon cinema opposite opened. It included an electric-powered clock mechanism and a clockwork cuckoo house. The cuckoo appeared on the hour, and even in the 1960s was loud enough to be heard over the noise of road traffic. It fell into disrepair in the 1970s until rescued by the Weston Lions Club, who renovated the mechanism and have planted many spring-flowering bulbs.

43. THE ODEON

Weston's Odeon cinema was designed by the Nottinghamshire architect Thomas Cecil Howitt, who also built the Bristol Odeon. The Weston cinema is notable for retaining many art deco features – both internally and externally – and still has its original Compton theatre organ, one of 361 similar organs by the John Compton's company. It was installed in 1935 and is thought to be the only cinema organ in the West Country in working order and in its original location.

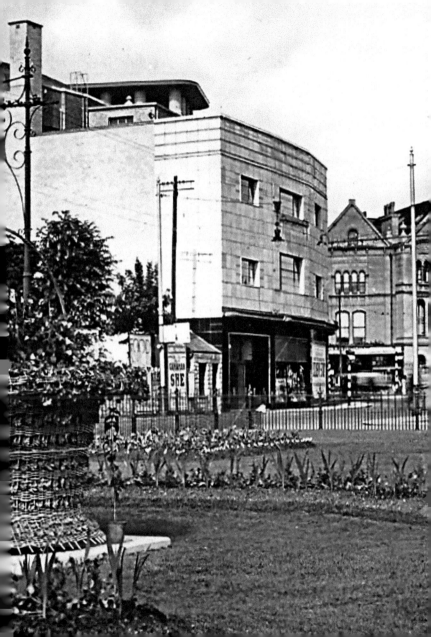

44. THE TOWN HALL

As it stands today, the Town Hall is another example of the work of Hans Fowler Price. Construction of the original hall began in 1858 and it was presented to the town in the following year by the former rector of Weston, Archdeacon Henry Law, following a dispute over the alleged vested interest in the land of a town commissioner. Price redesigned the campanile clock tower and added the south wing and entrance in 1897, and a further extension was completed in 1927. In 2011, the North Somerset Council undertook full refurbishment of the building and now occupies it, with the modern extension in Walliscote Grove Road, using it as its headquarters and as the town's library and police station.

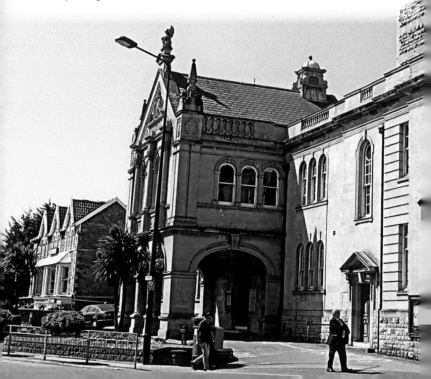

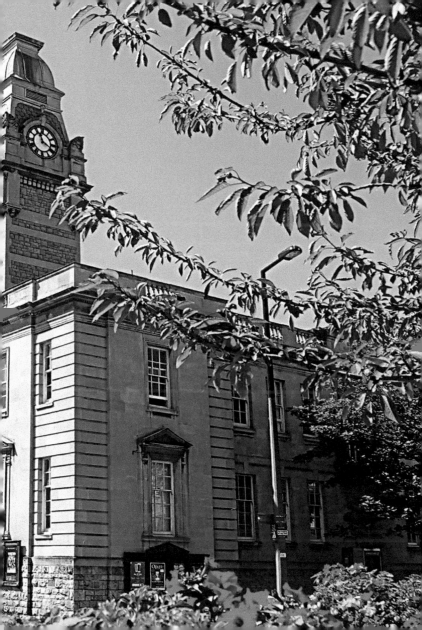

45. FORMER POLICE STATION AND MAGISTRATES' COURT

This austere building looked more inviting when the Portland stone façade was new and bright. It was designed as a magistrates' court on the upper floor with an integral police station below by Major A. J. Toomer, who was Somerset's county architect. It opened in 1934. Toomer lived in the hamlet of Dulcote, near Wells, and designed their village war memorial. The building, which is Grade II listed, has been described, rather harshly, as 'impersonal classical revival, with Fascist Roman details', but will be given a new life as luxury town centre apartments.

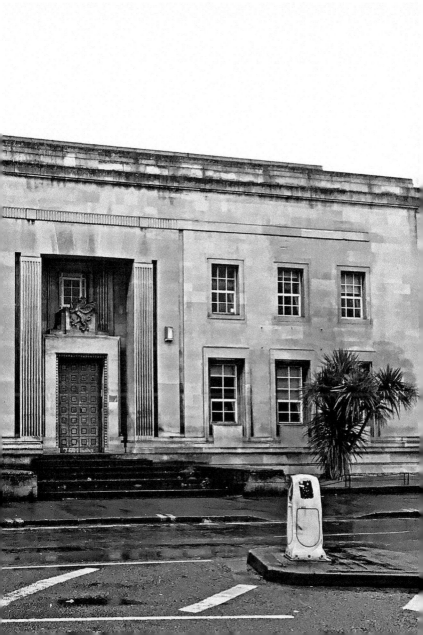

46. VICTORIA METHODIST CHURCH

Weston's first Methodist church was at the junction of Regent Street and St James Street. It was replaced by a much larger building in Station Street in 1900, which was destroyed in a fire on Monday 5 February 1934. Herbert 'Ted' Huntley, son of the owners of Huntley's Hotel in Regent Street, led the committee that rebuilt the church. Road widening meant a new building rather than restoration. The church has an impressive stained-glass window dedicated to those who died in the First World War, who included Ted Huntley's brother Alfred. The architects were Fry Paterson Jones, who had designed the extension to the former Municipal Library in the Boulevard in 1929.

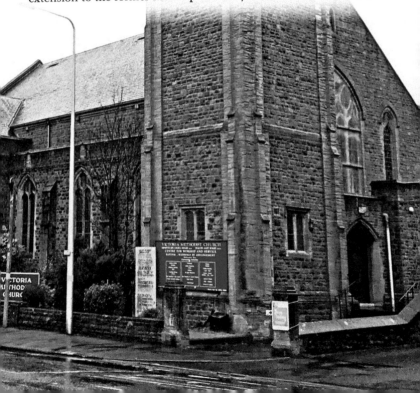

47. WALLISCOTE BOARD SCHOOLS

Hans Price became architect to the Somerset County Council Board of Education, but, with his colleague William Henry Wooler, tendered competitively for the contract for these separate boys' and girls' schools on a shared site, submitting a typically exuberant yet practical design. They were built by the local company owned by Charles Addicott. Completed in 1897, the cost was £20,000. The stone and tiles were all sourced locally. The main block is now Grade II listed. The building took the place of the old national school located where Weston College now stands.

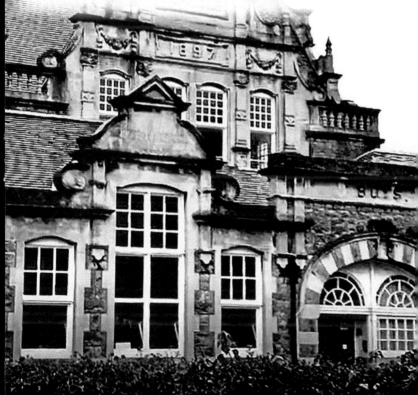

48. ELLENBOROUGH CRESCENT AND PARKS

Georgian-style elegance came to Weston in 1855 when Ellenborough Crescent was built, complete with stately private gardens stretching down to the sea. The parks included shrubbery walks, herbaceous borders and fountains. Now divided by Walliscote Road, the inland section is a protected haven for very rare plants. The section nearer the sea is used as a school playing field. The parks were subject to a landmark legal judgment in 1955 arising from compensation being paid to neighbouring homeowners following the occupation of the parks by the War Office during the Second World War.

49. CLARENCE PARK

These twin open spaces have provided recreational facilities for generations of townsfolk from the surrounding neighbourhood, as well as hosting such diverse activities as Somerset County Cricket and evangelical rallies. Divided into an east and a west park by the Walliscote Road, the park lies in the heart of the old Whitecross estate and was given to the town by Rebecca Davies, widow of Henry, in 1883. Mrs Davies also set aside the land next to the parks so that St Paul's Parish Church could be built to serve those who lived in the many terraces of houses built by her husband.

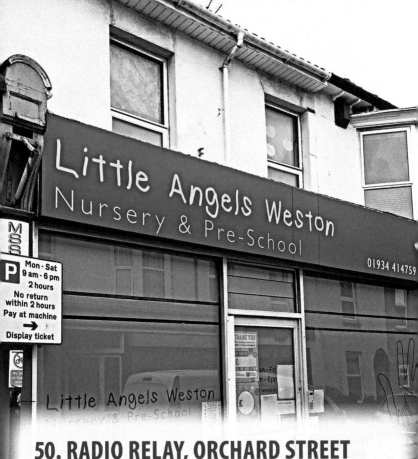

50. RADIO RELAY, ORCHARD STREET

These inauspicious premises, now a children's nursery, were where the batteries for Marconi's historic wireless transmission from Brean Down in 1897 were charged. William Badman (1879–1971) was the 'lad' who took the batteries to Marconi on the shop's bicycle. The 1911 census records him living on the premises with his family and running the business without any employees. He describes his occupation as 'electrical installation and repairs'. The shop later became Radio Relay.

51. WESTON MUSEUM, BURLINGTON STREET

This was one of Hans Price's last commissions, built as the Weston-super-Mare Gaslight Co. workshop and stores in 1912. This date can be seen in roman numerals on the frieze along the front façade. Price was the chairman of the gas company's board. It is now the home of the Weston Museum, owned by the town council and managed by a volunteer group, following refurbishment costing £1.6 million.

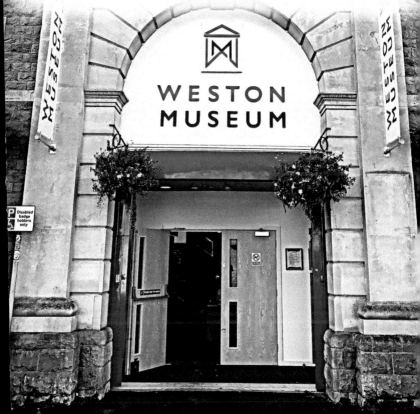

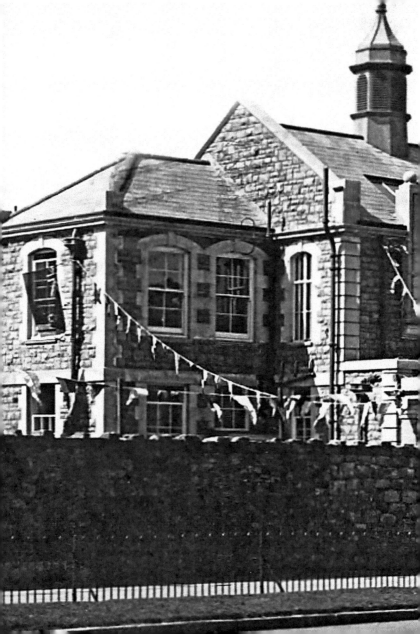

52. FORMER QUEEN ALEXANDRA MEMORIAL HOSPITAL

Henry Butt, Weston's most famous mayor, almost single-handedly raised the required £60,000 (£3.5 million today) needed to build this hospital. It was opened by the Duke and Duchess of York (later George VI and Queen Elizabeth, The Queen Mother) in 1928, in memory of Queen Alexandra, who had died in 1925. The building incorporated earlier premises in nearby Alfred Street. It served Weston for sixty years until the new hospital was constructed at Uphill. This fine building was saved from demolition and is now an apartment block renamed Henry Butt House.

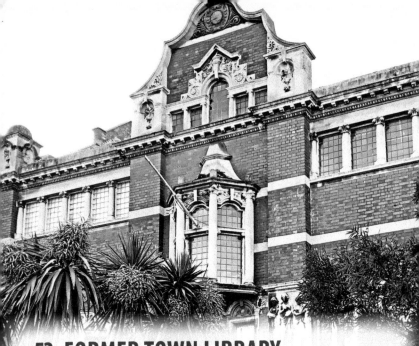

53. FORMER TOWN LIBRARY AND MUSEUM

Hans Price chose to use bricks rather than granite from the Cattybrook works near Almondsbury in Gloucestershire for this distinctive building. The company had supplied vast quantities of bricks for the Severn Tunnel. When this was completed in 1899, they were producing over capacity, so Price probably acquired the bricks for a low cost. The front façade includes groups of muses representing Knowledge and Education. These were commissioned from Harry Hems of Exeter, a prolific late Victorian ecclesiastical stone carver. The builder was Charles Addicott, the foundation stone was laid in August 1899 and the library was formally opened on 3 September 1900 by Sir Edward Fry, the president of the Library Association.